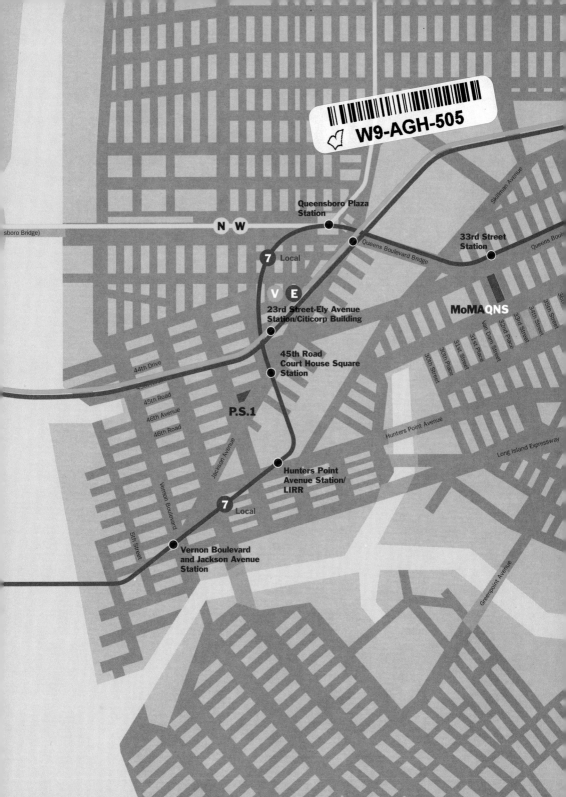

MoMAQNS
45-20 33rd Street (at Queens Boulevard)
Long Island City, NY 11101
(212) 708-9400
www.moma.org

I think I'll check out my favorite modern
paintings, drawings, and sculpture at
The Museum of Modern Art today.

How do you get to MoMAQNS?

by William Wegman

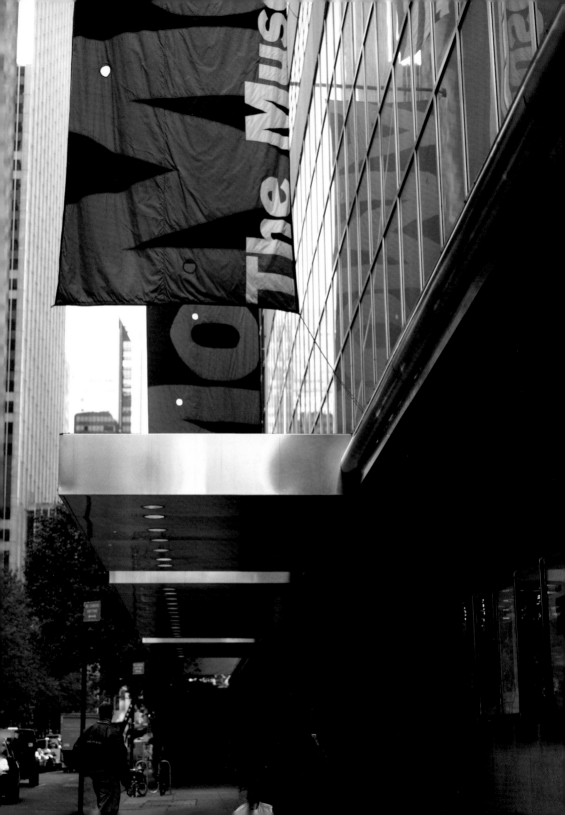

I always had a lot to look at and think about at MoMA
with over 100,000 paintings, sculptures, prints, photographs,
architectural models, drawings, and design objects...

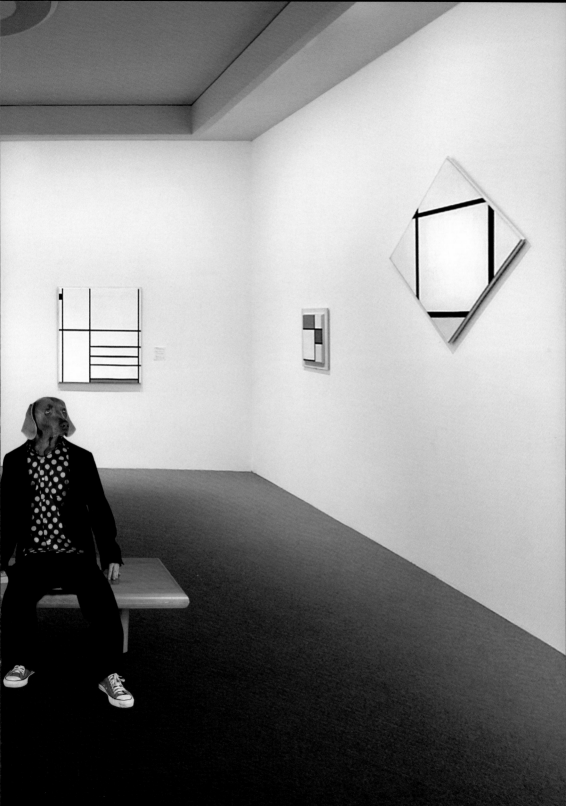

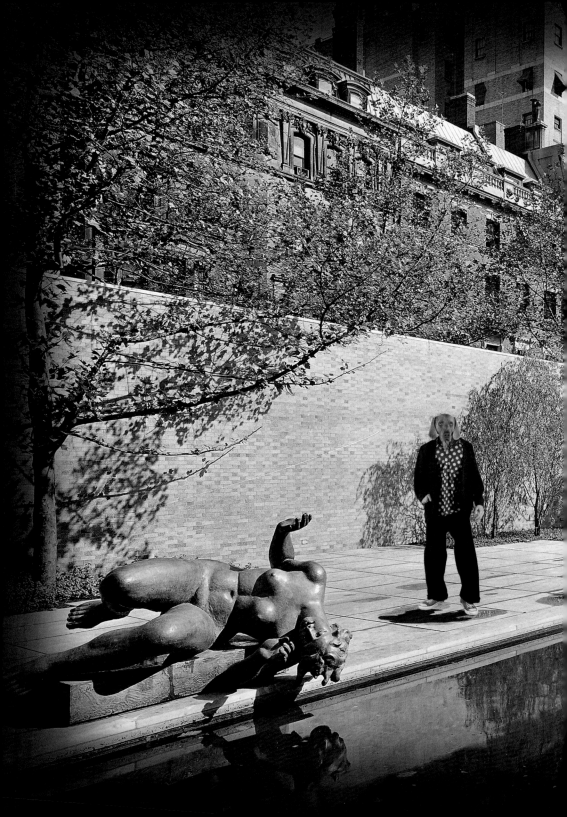

...as well as 18,000 films, 10,000 posters, and 180,000 books.

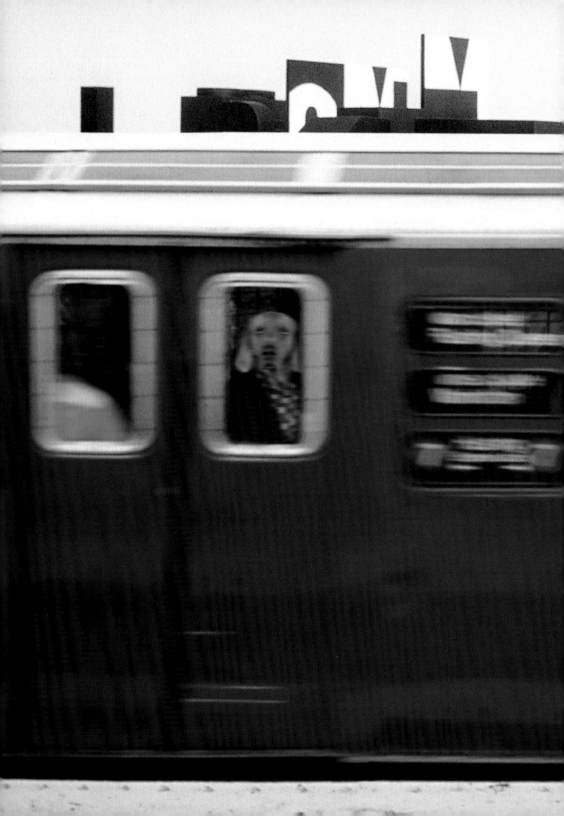

What a view! This is a real adventure. Hey, look, there's P.S.1.
Am I in Long Island City? Am I lost? Wait, no, it's a part of
Queens too. Brooklyn must be just over there.

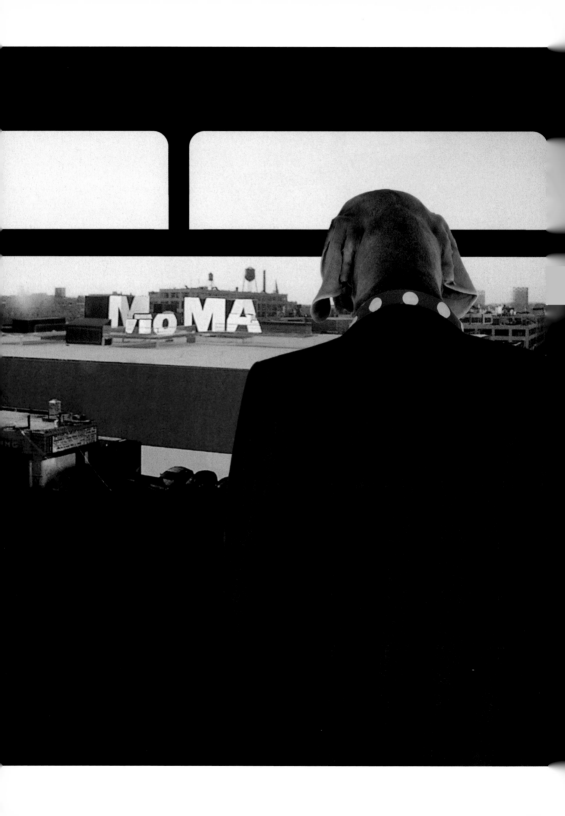

Look at that striking long blue building. That must be where the collection is being temporarily housed. Could that be the old Swingline Staple building I once visited as a kid?

Here we are, Queens Boulevard and 33rd Street. That was a cinch. It took less than ten minutes from midtown on the ⑦ local train.

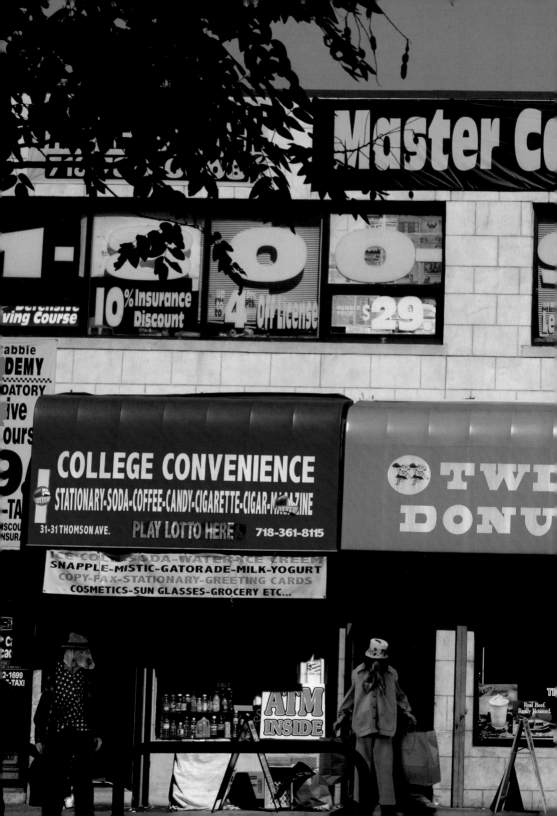

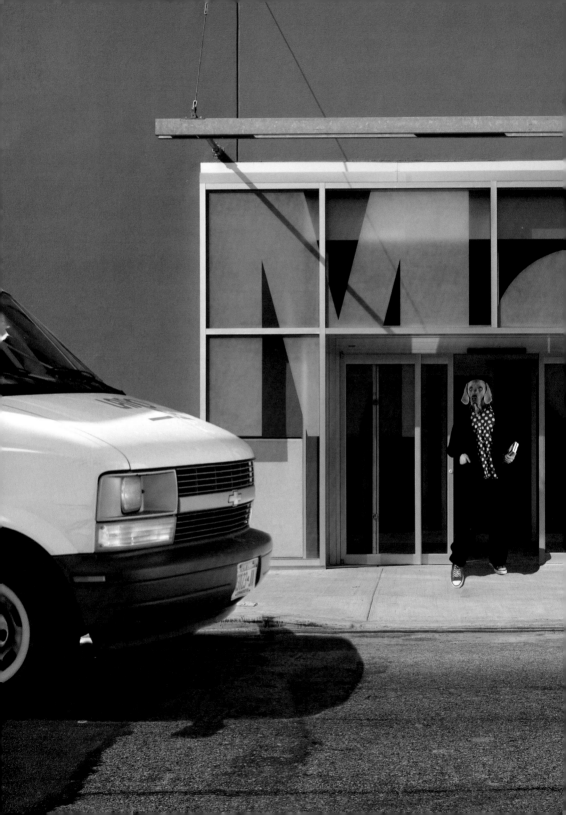

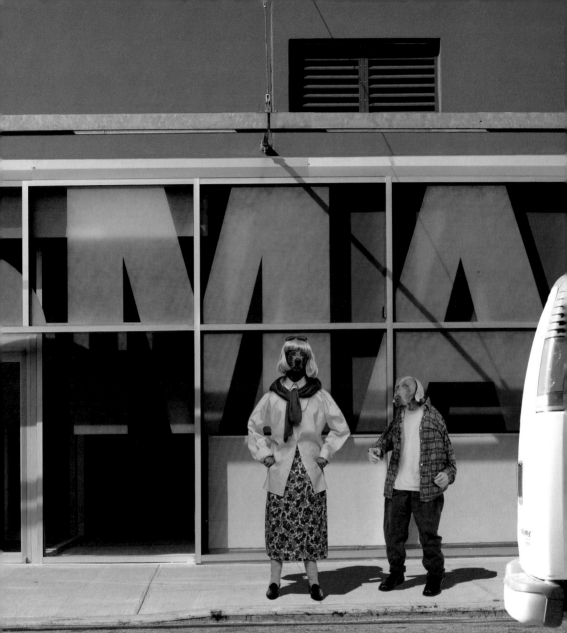

Big M little o Big M Big A Big QNS. The Museum of Modern Art.
The world's foremost museum of modern and contemporary art.

If it's after June 29, 2002, between l0 a.m. and 5 p.m. (except
Tuesdays and Wednesdays) I can go in and view the collection.
Or there's always Fridays until 8... Does anyone have the correct
time and date?

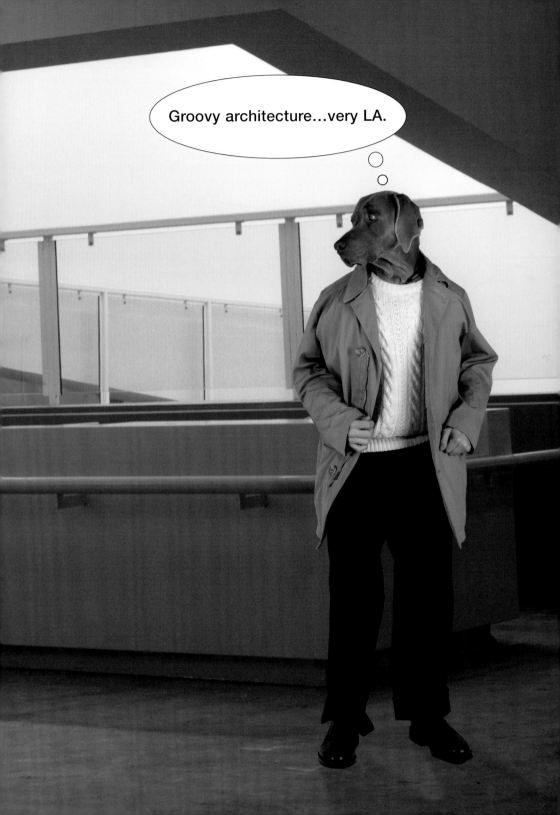

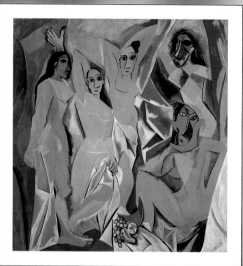

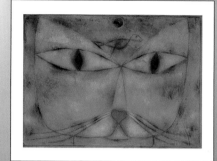

Picasso, Klee, Matisse. I see the bookstore and now the café. I look up and before my eyes what do I see? A mezzanine. And over here is the projects room showing…someone I've never heard of. This is amazing. My cup runneth over.

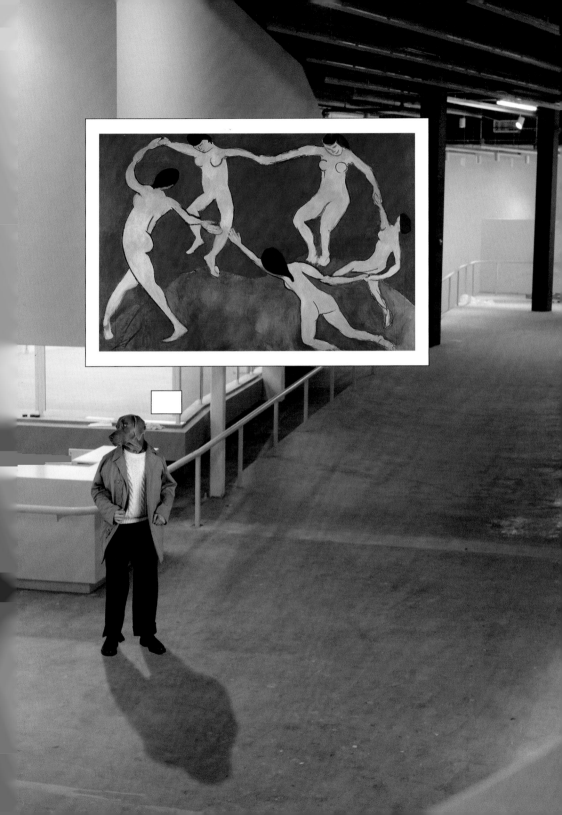

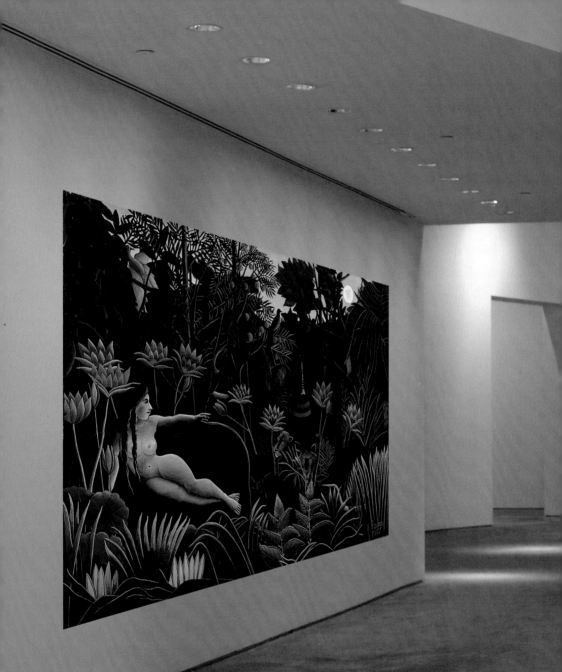

Now I have something to do until 2005. It was so easy to get here! I'll come whenever I can.

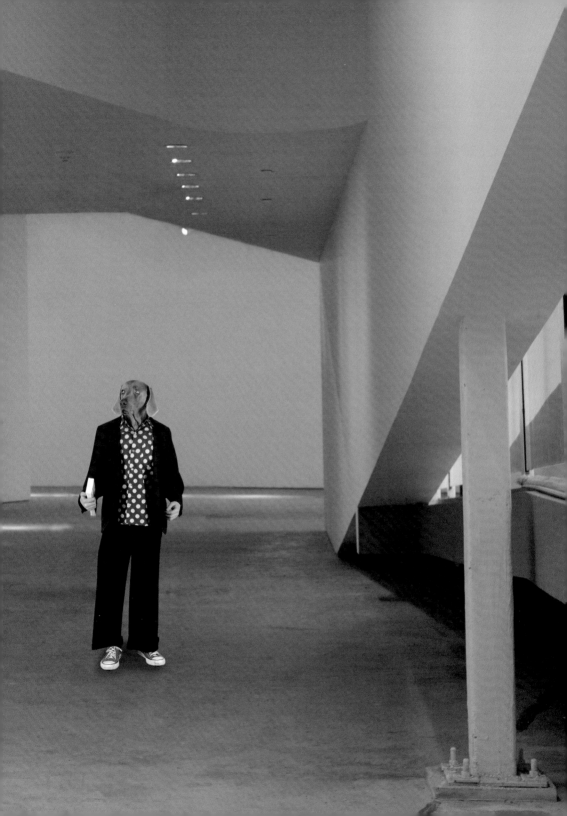

Oh well, I better get back to Manhattan. I'll reverse my steps and take the upside-down-backwards **Ɫ** to dnarG lartneC noitatS. Now I'm in a time capsule and here I am in Manhattan at the new MoMA.

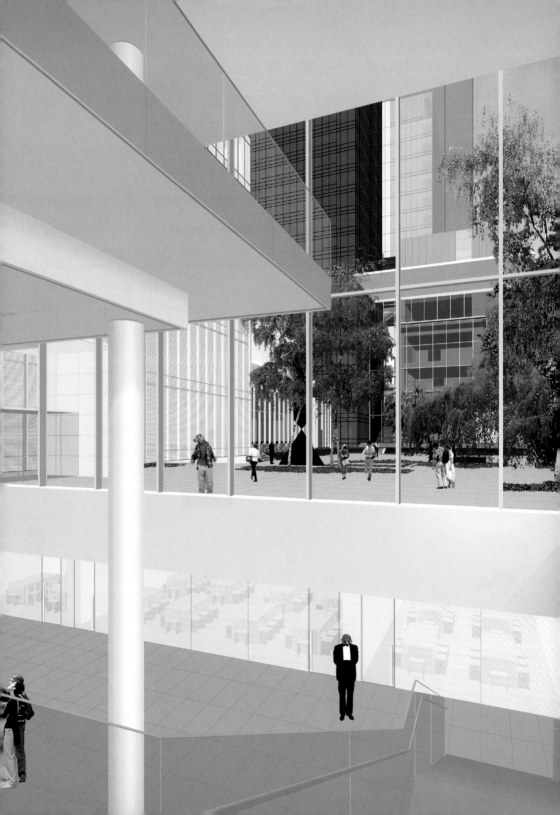

This book is published on the occasion of the
opening of MoMA QNS, The Museum of Modern
Art's facility in Queens, New York

This publication is made possible by Agnes Gund
and Daniel Shapiro, Jo Carole and Ronald S. Lauder,
and Joanne M. Stern

Produced by the Department of Publications,
The Museum of Modern Art, New York
Edited by Mary Lea Bandy, May Castleberry,
and Amy McLaughlin
Designed by Empire Design Studio, NYC
Digital Imaging by Jason Burch
Production by Marc Sapir
Printed and bound by EuroGrafica SpA, Vicenza
Typeset in Helvetica Neue
Printed on 150 gsm Biberest Allegro

Library of Congress Control Number: 2002105035
ISBN: 0-87070-689-6

Published by The Museum of Modern Art
11 West 53 Street, New York, New York 10019

Distributed by D.A.P./Distributed Art Publishers,
New York

Printed in Italy

Acknowledgments

For all they do, I would like to thank Agnes Gund and Daniel Shapiro. This guide to
MoMA QNS would not have been possible without their generous contributions, as well as
those of Jo Carole and Ronald S. Lauder and Joanne M. Stern.

I want to thank Jason Burch for his photography and digital expertise and Gary Tooth
of Empire Design Studio for all his help and patience with this book. I would also like
to thank Christine Burgin, Marlo Kovach, Erick Michaud for lending Chip his hands, Ariel
Dill, Catherine Ecclestone, Larry Lipnick, Patrick O'Rourke, and Pam Wegman.

At The Museum of Modern Art, May Castleberry, Editor, Library Council Publications, and
Mary Lea Bandy, Deputy Director of Curatorial A ffairs, first invited me to think about this
project. I would especially like to thank Mary Lea for her vision and her persistence in seeing
the project through to completion and May for her ideas and her support throughout the
design and publication. I would also like to thank Amy McLaughlin, Assistant to the Deputy
Director of Curatorial Affairs, for her help in coordinating all aspects of the project.

Grateful thanks are due to Glenn D. Lowry, Director of the Museum, and Kynaston McShine,
Senior Curator and Acting Chief Curator, Department of Painting and Sculpture, for their
enthusiasm and kind cooperation. Among many others at the Museum I would also like
to thank Nancy Adelson, Louis Bedard, Elizabeth Burke, Mikki Carpenter, Ingrid Chou,
Kate Keller, Erik Landsberg, Michael Maegraith, Michael Margitich, Ed Pusz, Marc Sapir,
and Chris Zichello.

Photograph Credits

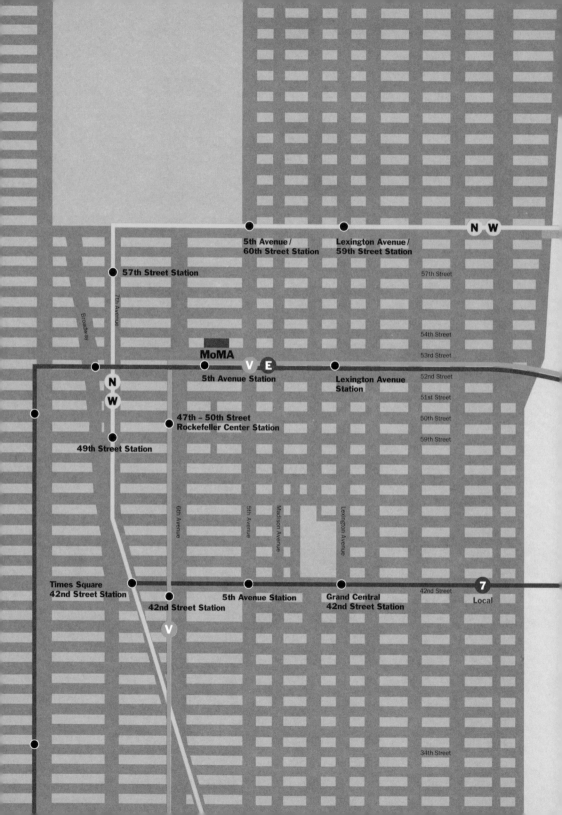